June, 1981

When life gets too hectic or
exciting... here's a
tranquilizer —

Fondly,
Debra + Jerry
Kramer

MOODS

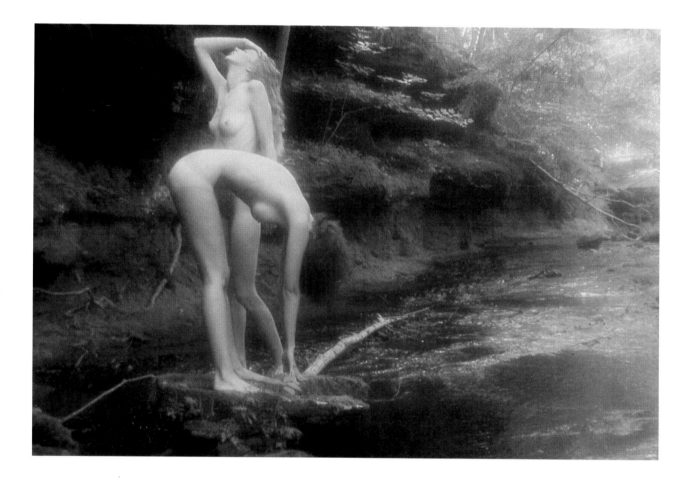

MOODS
ROBERT FARBER

AMPHOTO American Photographic Book Publishing
An Imprint of Watson-Guptill Publications/New York

To my son Lee.

First published 1980 in New York by
American Photographic Book Publishing,
an imprint of Watson-Guptill Publications,
a division of Billboard Publications, Inc.,
1515 Broadway, New York, N.Y. 10036

Library of Congress Cataloging in Publication Data

Farber, Robert.
　Moods.

　1. Photography, Artistic.　I. Title.
TR642.F37　　779′.092′4　　80-18797

ISBN: 0-8174-4900-0

10 9 8 7 6 5 4 3 2 1
The last number shown above denotes the printing
of this book.

Manufactured in the United States of America.

MOODS:
THE PHOTOGRAPHY OF ROBERT FARBER

By Donald Goddard

FOREWORD

Written interpretations of photography often revert to a discussion of ƒ-stops, types of film and film speeds, darkroom techniques, and the lengths to which a photographer will go to get a certain shot. Until recently, the medium has been a poor relation of painting, too dependent on reality to be considered art. But photography, like any art form, is a product of imagination as well as a rendition of observable reality, and can therefore be appreciated within the broad spectrum of human experience and thought. The technology of Robert Farber's work, though often complex, can be stated in fairly simple terms. But it is the deeper consideration of his art that concerns us here, in particular how it shapes and reflects visual and emotional consciousness. Farber's pictures transcend anything that can be said about them, and the effect they have depends on what interpretation each viewer brings to them.

Donald Goddard is the author of several books and essays on art and photography, and is a former Managing Editor of ARTnews *magazine.*

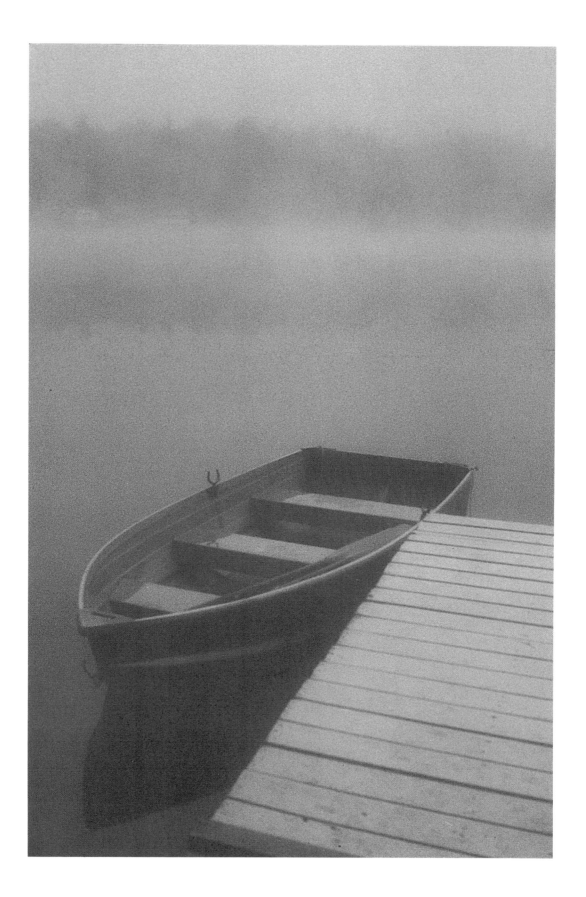

INTRODUCTION

Every moment has a mood. People are subject not only to their own temperaments, but also to the seasons, the weather, time of day, success or failure, love or hate, literature, music, and art. Although the routines of everyday life often dull our sensitivity to them, moods still determine the way we look, move, talk, act, and feel, as well as the way we perceive everyone and everything. They reflect our constantly shifting emotional existence.

The photographs of Robert Farber capture mood at its most transcendent, at the fleeting instants in which seemingly mundane objects enter the realm of feeling. In them our ordinary consciousness, conditioned by disruptions, distractions, and commonplaceness, is replaced by a larger sense of time, space, and light. Each picture is a fragment—of a landscape, a room, an object, a human form—and yet complete in itself. For the moment only that fragment exists—an old sink played into an intricate pattern of light and shadow, the perfect sinuous profile of a woman's hip, an ancient farmyard in a desolate landscape. Nothing interrupts the essential mood and integrity of the picture, which is defined by the unique structure of light, form, color, line, gesture, and expression.

But making a picture involves more than simply recording evocative atmospheric effects, picturesque textures, and sensuous contours. It is a complex aesthetic process in which the elements that contribute to the overall mood and meaning are instinctively analyzed and understood, then reconstituted on the flat plane of the photograph. What existed in reality is translated photographically into an integrated pattern. The original mood is recreated and even intensified in photographic terms, because only what is essential is retained. The dominant characteristics of color, light, and form become part of the inner reality of the picture, held in balance within the total image.

Mood into Style

To achieve the image that corresponds with his original impulse, Farber uses the technology of photography fully. The final form of the picture depends on a subtle manipulation of various types of film, film speeds, lenses, filters, filtering substances, and exposures. If a mood is created by a diffusion of light, that effect can be enhanced by filtering, by selective exposure, or by pushing the film during development to break up the emulsion. Illumination can be emphasized by overexposing certain areas, and dominant tones can be brought out by filtering or changing the type of film. However, all these techniques are secondary to merging the initial impression with the photographer's vision.

It is not, in other words, a matter of forcing the medium, or of distorting reality, but of composing what is there into a coherent whole. Mood is elucidated rather than fabricated. Natural order—the perspective of a line of trees, the patterns created by light, shadow, and reflection, the way a nude form blends with the contours of a room or landscape—becomes pictorial order, the cohesive organization of the picture surface. There is thus a constant and powerful reverberation between the real and the aesthetic, an interlocking of the two worlds that defines the special nature of photography.

Farber finds his images in the open countryside, in abandoned houses, or in his own studio—away from the clutter and confusion of modern life. There is an air of seclusion and deep communication between the photographer and his subjects. The world he portrays is intimate and personal, perfectly natural and yet a reflection of his most profound feelings. The moods are both his and those of the places and scenes he photographs, permanent and timeless states of reverie in which time, light, and image are suspended.

TRADITIONS TRANSFORMED

In the nineteenth century photography was both the result of, and the catalyst for, a new attitude toward visual experience. The possibility of actually recording what one saw and, in later years, of investigating the most minute variations of light, movement, expression, and even microscopic and cosmic events, was accompanied by profound changes in the visual arts. William Turner, John Constable, and the English Romantic painters of that century were the first to scrutinize and depict the effects of weather and atmosphere in a consistent and almost scientifically scrupulous way. For the Impressionists, the overriding concern was the analysis of light in terms of color, and breakdown of color into its components under varying atmospheric conditions.

Painting in the twentieth century has become even more specialized. From Cubism through the various branches of abstraction the emphasis has been on the mechanics of perception, knowledge, the unconscious, language, and art itself. Photography, on the other hand, has taken up visually observed reality where the Impressionist painters left off. There have been crosscurrents between painting and photography—in the areas of Surrealism, abstraction, Pop art, and other trends—but for the most part, photography has retained its own identity as a medium.

The Photographer as Artist

Along with the overall ambition of his work, Farber's pictorial language also became more painterly. Painting and photography are, after all, comparable. Both are arrangements of color, line, form, and space on a flat surface, although the materials are different and one depends on manual, the other on mechanical intervention. In a sense, the painter has greater freedom to invent his own style. The very act of drawing and putting paint on canvas is a signature. The photographer, on the other hand, must accept the subject in a more literal way, manipulating the image and his participation in it by more remote, technical means. Photography is therefore restricted by what nature provides. The natural appearance of things cannot be significantly altered without resorting to contrivance. The vividness of the image as a facsimile of reality would seem to preclude the establishment of aesthetic order. But it doesn't. Nature itself provides an order, whether we always perceive it or not. It is this order which moves both painters and photographers in the first place.

For this reason, Farber understood that the lessons of painting are also applicable to photography. It is not a matter of trying to make photography look like painting, but of understanding the relationship of elements within the total format of the picture. In Farber's work, image and order coincide; one cannot exist without the other. This is evident in the photograph of an old man carrying an umbrella at the end of a narrow alley, taken in Portugal in 1969. The mood depends not only on the subtle expressiveness of the figure and the mellowed surfaces of the walls, but also the way these elements are balanced and interwoven, the way in which the small, black accent of the man focuses the perspective as well as contrasts with the broad, flat monochrome of the walls. Forms and colors become abstract elements and at the same time retain their identity. One remembers the scene in terms of drawn shapes, painted colors, and constructed space, and yet the reality of it is never in doubt.

Forerunners of Photography

Throughout his career, Farber has been mindful of painting as the model for a more comprehen-

sive vision. He is attracted particularly to the seventeenth-century Dutch painters and the nineteenth-century French Impressionists, the major forerunners of the photographic attitude in their almost scientific fervor toward the study and depiction of visual phenomena. These two schools represent different, almost opposing, tendencies, with the Dutch preferring the direct lighting of objects, figures, and space and dramatic contrasts of light and shadow, and the Impressionists preferring an overall effect of light on color and atmosphere. Dutch painters were the first to consistently depict the natural and particular role of light in defining what we perceive of the world. In the works of Rembrandt, Vermeer, and others, color, form, and texture exist because of light, and the organization of the picture plane itself depends in part on the way these elements are revealed by light or obscured by shadow. Light is the symbolic equivalent of consciousness. The Impressionists, on the other hand, were interested in the all-embracing effect of light on color. They envisioned a continuous field of diffused color in which forms and space are composed of tiny particles of color merged into the overall pattern.

The Essence of Photography

Both approaches exaggerate for aesthetic purposes. Natural and artificial light actually produce an infinite variety of effects and moods, ranging from the dark–light contrasts of Dutch painting to the all-over color fields of Impressionism. To Farber, the work of these masters suggested pictorial ways of dealing with light, which is, after all, the very essence of photography. His aim was not to imitate their methods and effects, although his work often evokes the association, but to achieve a comparable tactility of light, to wed light with color and form on the surface of the picture. Whereas most photographers treat light as transparent, Farber gives it substance by confining it compositionally in planes of color, or by emphasizing its natural diffusion. Light becomes opaque, an almost material element that forms the fabric of the picture plane, and is intrinsic to the entire field of vision rather than external and incidental. Light is the raw medium of the photograph, the stuff of which it is made, just as pigment is the medium of painting.

Light-Textures

Unlike painting, however, photography depends primarily on light-textures that already exist. Everything we see has this quality, but our awareness of it is usually subordinated to other concerns, or is lost in the general chaos of everday vision. In Farber's work, it is always present. One kind of light-texture results from the combination of light and atmosphere, ranging from the almost granular diffusion of fog and mist to the glossiness of a clear, sunlit day. It creates a uniform materiality within which all colors have the same tonal qualities, all linear elements have the same degree of clarity, and all surfaces have the same consistency.

In some conditions of light or weather, for example, darkened rooms or heavily overcast days, colors are reduced to an almost monochrome field, which in itself creates a kind of pictorial unity. The same is true of monochromatic photographs taken in bright light, but here the actual texture of objects becomes a more important factor. Examples of this include a field of dandelions, or the marsh grass of a Maine inlet. When the colors separate into distinct areas, as in the photograph of a nude torso against the sky and dunes in Martinique, the fabric is like a patchwork quilt or a modern painting of geometric abstraction, in which unity depends on a balancing of color forms.

The varieties of light-textures are infinite and each evokes its own mood. Farber seems to find situations in which the texture of light is at its most intense and all-encompassing, as though to embrace and extend the purest moments of perception. Whether the subject is a broad landscape or a single object, every element partakes of the same ambience, which in a sense represents the photographer's sensibility, his focus of thought and emotion. He skillfully combines the immediacy of photography and the abstract power of painting.

TIME AND
TIMELESSNESS

One measure of consciousness is time, which in photography is expressed perhaps more immediately and poignantly than in any other art form. The photographic process itself is one of time exposure and timed development. Because they are records of events, situations, people, and places, and because we know that what we are seeing actually existed, photographs have an uncanny power to produce a profound sense of *déjà vu*, nostalgia, or historical pathos. What we remember of our childhood, for instance, is often filtered through snapshots that replace or augment memory. In Farber's mood photography, that power is intensified in an almost abstract way: the moment, the fleeting passage of a mood fixed in time, primarily as a function of light. Early-morning light, late-afternoon light, winter light, and summer light become the conveyors of a larger time sense that merges with the rhythm of days and seasons.

Farber's photographs introduce a different time scale than we are accustomed to, closer to the tempo of nature. Our lives are dominated by schedules for every activity we engage in from waking to sleeping. Time is an artificial arrangement of events within which thought, feelings, and the natural development of consciousness have difficulty finding a place. Through his photographs, Farber returns to states of being—pastoral, sensual, and meditative—that are at once timeless and filled with the time of human and natural history.

Fashion vs. Imaginative Photography

Most of the photographs were taken during time set aside from Farber's work as a fashion photographer. In this respect, they represent both a renewal of his visual resources and an escape from the rigors and pressures of the fashion world. There is no doubt that the two fields interlock and affect each other in certain ways, one providing an incredible awareness of every detail of lighting, texture, color, and expression—the perfection that is required in advertising a product—the other providing a general approach to the feeling and style of a picture. But fashion photography is geared toward fast action and a complex orchestration of models, locations, props, makeup artists, hair stylists, and pre-planned scenarios. It proceeds according to schedule within a restricted period of time and generally adheres to the requirements of the client or product.

The imaginative work, on the other hand, promotes a more personal universe. Except for those done in his studio, most of Farber's photographs were taken during his travels in the countryside around New York, in Europe, the Caribbean, and the western United States. The pace is leisurely. Time is open-ended rather than proscribed, and the subject is often a matter of chance rather than arrangement. The process is one of visual and emotional awakening, a solitary journey of discovery.

Technology vs. Natural Time

By literally entering another time frame in his travels and in the pictures themselves, Farber proposes an alternative to the harshness and artificiality of modern life, an antidote to the bombardment of images by television, newspapers, magazines, advertisements, and other mass media. His own medium involves a sophisticated, modern technology, but its apparatus and virtuoso capabilities are always subordinated to the underlying spirit and structure of the subject and Farber's own vision. The versatility of the camera and its accessories allows him the freedom to recreate on film a

complex set of conditions. Farber uses the camera for its extreme sensitivity to the subtle contrasts and changes in nature. He uses fast film and fast lenses not to stop fast, dynamic action—which in any case is a contradiction—or to capture odd juxtapositions of images, but to illustrate the moment at which all the elements of light, color, and form contribute to the total mood and structure of a picture.

The merging of the camera and natural time is most vividly felt in Farber's landscapes and outdoor scenes, where the effects of light and weather are universal. Camera and photographer seem to be inside nature, aware of the total din of sensual experience, of sound, smell, touch, and sight. The wind creates constantly changing patterns of color and texture in a field of grass. Clouds alternately obscure and reveal objects and whole areas of landscape. The quality of sunlight shifts infinitesimally with each passing moment.

And yet stillness prevails in Farber's photographs, even in the busiest scenes of dappled forest light or riotously colored fields of flowers. All the viewer's senses are absorbed in the texture of light, the undulating line of a sand dune, the graceful contour of a rowboat on a Maine inlet, or the warm glow of a woman's body. Each picture has a distinctive shape, or convergence of shapes, into which the infinite variety and evocative powers of nature are distilled. They are like geological cross-sections that reveal the density and depth of a given instant. What one sees has never been seen and never will be seen again and yet it is totally familiar.

Double Perceptions

The familiar becomes the sublime. An old man sits in a beach chair under an umbrella, gazing out at the sea and sky, his cane hooked over one arm of the chair. There is nothing extraordinary about the scene except its deceptive simplicity. With the naiveté of a child's drawing, the sky, sea, man, chair, umbrella, and cane are blocked out in elementary shapes and colors. But the intricate balance of shapes and colors transforms the familiar into the universal. Consequently, the picture we see is far more complex than the scene the man sees of the sea and sky. What he sees is also seen by us, but through the imaginative space and time of the

man's reverie. The simple division of sea and sky becomes a complex division into the accoutrements of the man's being. In other words, we experience both the man and his thoughts of the landscape before him. The image is out of time, and yet is the very essence of time in the old man's life.

Time as an Historical Process

Another kind of time and light fills the photograph of a desolate farmyard in New England. The stark forms of an old barn, a broken-down fence, and a huge dead tree loom out of the purplish haze of early-morning light. The subject is perfectly suited to the eerie monochrome cast, which seems to erode the barn, fence, and tree just as they have been eroded by time. Here, the dimension of time is expressed not only as a particular moment, but also as an historical process. The old building, fence, and tree stand as measurable links with the past. One sense of time telescopes within another, extending to larger and larger realms of time—from moment to day to season to the farm's history to the primeval history of the landscape itself.

The mood emerges from the layering of time in infinite regression, casting a spell of unconscious memory that even the living presence of the horse does not break. In shooting the scene, Farber was intensely aware of the horse's movements, while trying to avoid being noticed and thereby interrupting the overall mood, even with so minute an element in the panoramic breadth of the picture. When, finally, the horse casually touched the fence with his nose, the picture was complete, the gesture of the horse merging with the general sense of unconscious time.

Like the paintings of the past, the old buildings and objects that frequently inhabit Farber's photographs play an important role in his pictorial language. They express a depth of experience and continuity of time that joins man with nature and past with present. New England is the site of many of his photographs because of its historical richness and its association with old-world culture. Its rustic buildings and artifacts have undergone the alterations of time and become part of the landscape, taking on the tone, atmosphere, color, and form of the surrounding environment.

INTERIOR
LANDSCAPES

The intimacy that pervades even the most panoramic of Farber's landscapes is also perceptible in his photographs of interiors and still lifes. Enclosed walls create a mood and space that are more akin to domestic tranquility than to the urgings of primeval nature. Farber's interiors are treated as sanctuaries of private thought and feeling, and the figures that sometimes appear in them are pensive and withdrawn. The impression of sanctity is reinforced in pictures taken in churches and other buildings with religious associations. Physical and spiritual confinement brings objects and surfaces closer, making us aware of their materiality, the properties that define their existence. Still lifes glow with the mysterious presence of ritual artifacts. We begin to see the special qualities of form, color, and texture that distinguish even the most mundane and familiar aspects of our immediate surroundings. We feel movement toward an inner reality rather than toward an outward expanse of infinite space. An interior or still life is like a landscape turned outside in, with the horizon condensed into the most intense point of contact between ourselves and the subject.

Perception follows the path of light inward. It enters through windows, moving from the outside in, etching forms in the darkness that is the natural state of an enclosed space. Light contrasts and mingles with darkness in the same continuous field. One is simply the reverse of the other, part of the same substance. They merge dramatically and graphically or gradually and imperceptibly. Objects come into being somewhere within the range between the deepest recesses of shadow and the white, featureless glare of full light. The point at which an object reaches the full potential of its nature, however infinitesimal, is the point at which the photograph is made. For instance, an old water pump in the corner of a garage, unused and for-

gotten for years, suddenly, in a certain light, takes on an ethereal aura. The hard light exploding through the window seems to converge with the dense shadows, meeting on the metallic surface of the pump and creating there an incredible mixture of cool and warm tones.

Atmospheric-Aesthetic Qualities

In interiors, Farber looks for the same qualities he would seek in a landscape: strong atmospheric or textural effects, seclusion and intimacy, man-made structures that show the passage of time, compositional unity, and total mood or feeling. They are like interior extensions of the landscapes he has photographed in New England, Europe, and elsewhere. The sites—an unoccupied summer mansion in Southampton, a room in the old Black Bass Inn in Pennsylvania, a deserted farmhouse in Massachusetts, a church in England, Théodore Rousseau's painting studio in the Forest of Fontainebleau, a convent in New Jersey—all have suggestive associations with the past and vivid aesthetic possibilities. Though uninhabited or abandoned, they are nonetheless filled with the subtle evidence of human use and presence: a curtained window, an old chair, a dismantled light fixture, peeling walls, a vase of flowers. At the same time, one cannot imagine normal habitation in these places. People have been replaced by the remnants of their existence. Figures of nudes inhabit rooms as though in a dream. The spaces have become environments of pure evocation which, in Farber's photographs, is the heart of mood.

Dramatic Interiors

Interiors focus the drama of discovering and recording mood. This sense of discovery is part

of Farber's outdoor shooting as well, where conditions of place, light, and movement converge to create dramatic moments of mood. There is often a theatrical element outdoors —shafts of light falling through thick forest foliage, bright contrasts of color in a field of flowers, a subtle gesture, an idyllic natural setting located just twenty miles from the city. But in an old, abandoned house or church, the possibilities for unexpected drama are intensified. Light, for instance, is often more concentrated and directional indoors and therefore creates dramatic highlights and patterns of light and shade. Forms, textures, and surfaces are imbued with a special, heightened quality by the light that falls on them.

Objects, such as the water pump, are discovered in curious and unexpected places, so that one is forced out of normal habits of viewing them. The effects of such places haunt us as no landscape can. The concentration of light and space also focuses greater attention on immediate surroundings, on the formal and textural beauty of fragments and details of the total visual field, such as the old sink or the weathered door. An object becomes tangible in a way that distant landscapes cannot be, and is therefore a more intimate part of our experience, something that can be touched and explored with a refined sensitivity to its inherent characteristics. Isolation from the outside world intensifies the relationship between photographer and subject.

Photographing Interiors

Photographing an interior is filled with the intrigue of entering a private domain, of playing out a very personal experience hidden from the rest of the world. It is like being privy to some secret that is visible only to the eye of the camera. Each photograph is a test of the photographer's ability to see and feel more deeply. In photographing an interior, light and focus, as well as the photographer's perceptions, reach a critical level at which camera and film must be used with extraordinary sensitivity. Shooting with a wide-open lens, or with a long time exposure, entails problems with focus and depth of field. All these considerations become part of a complex process of compensation in which certain areas may be overexposed in order to bring out the detail in others, but without destroying the total ambience and mood. The aim is to bring out what is there. Introducing another source of light will simply eliminate the original mood. The purest still lifes are those which are photographed with as little intervention as possible by the photographer. And yet a photograph is a product of absolute intervention, in that it recreates what exists in the photographer's vision. The camera, like the eye, operates on the delicate edge of perception and is no more, no less, than an instrument finely tuned to an inner vision. In Farber's work, still lifes and interiors present the greatest challenge to this vision, both technically and emotionally.

THE GRAPHIC NUDE

In art, and that includes photography, the female nude has always been the ultimate embodiment of beauty and aesthetic emotion. No other subject engages our senses with quite such insistence, with the exception perhaps of those which arouse feelings of fear and awe. This attraction to the female nude is even more powerfully stated in photography because the figure is closer to reality. What we notice first in any photograph of a nude woman, is her nudity. We are familiar with the beauty of art because we are familiar with the seductiveness of nature, and of the female form. The source of that beauty is impossible to define; we know it only when it appears as a certain arrangement of line, color, and form, and never more so than in the conformation of the female body.

Simply put, the nude is a measure of aesthetic perfection. In Farber's work, she is the essence of form, of sensual line and surface. Her contours summarize the rhythms of nature and graphically compose the picture plane with greater perfection and grace than any drawn line. Light seems to intensify in the softness and smoothness of her flesh. Every element of the surroundings and the picture is focused in her form.

The Nude as Focal Point

When a nude is introduced into a scene, particularly a landscape setting, she automatically and literally becomes the focal point. The setting is basically stationary, but whatever subtle changes are made in the intensity of light and color become subordinate to the nude's movements and final domination of the picture space. Success in arriving at this point depends on an intimate and usually wordless communication between Farber and the model. Each feels the other's participation in the mood and contours of the setting as well as in the changes that are constantly occurring. The model moves fluidly from one position to another until the shape of her movements focuses the structure of the landscape itself. Farber's own movements complement those of the model to create a unified composition.

Improvisation leads to an almost effortless harmony in Farber's work. Each picture represents the climax of a complex and constantly developing set of relationships, however succinct the final image might be. The pieces of the picture of a nude reclining in a field of white flowers fell into place when it became clear that shooting only a part of her body produced a more pleasing and unified effect. By simply suggesting the female form, Farber was able to retain a consistent quality of tone and light and to contrast the smooth sensuality of the form with the textural sensuality of the field of flowers. The soft glow of the model's milky-white skin was emphasized by underexposing that area. The image has an intensity which a view of the entire nude and a wider range of colors would not have produced.

Merging Human and Natural Form

The underlying conformations and subtle contrasts of linear, tonal, and textural elements vary with every photograph. In a scene shot in Martinique, the figure seems to grow into the huge, twisted tree trunk. Exposure for the darker foreground increased the intensity of the background light and eliminated sharp contrasts of color. This, and the use of hairspray on a diffusion filter, helped to create an ethereal aura that further fuses the figure and tree. Everything seems to be made of light, especially the model's very blond hair, which imbues the composition with a particular radiance. Here, color has a molten, liquid quality. Here, too, the sensuousness of

nature is given a special meaning by the female form.

The meaning suggested by this merging of human and natural form, the identification of woman and nature, resides in the regenerative power of both. The images combine, literally join in the structure of the picture, to evoke the mythical ambience of an earthly paradise or Garden of Eden. There is a sense in many of these pictures of life awakening through the female form from a state of nature—figures receiving or contemplating early-morning sun, the source of life, or emerging, like nymphs, from the dense plasma of nature, from streams, vegetation, meadows, trees, or rocks.

The Nude as Form

Farber often uses the contours of the nude as a form of drawing, which is the initial creative or generative act of the artist. The lines that define the nude become the basic graphic element in the overall design. An intriguing example is a view in which the profile of a nude actually blocks out the sun and thereby establishes a shape that divides the picture into three parts. The dark, smoothly contoured form seems to be painted or drawn onto the surface of the deep landscape.

But whether the form is perceived as graphic or painterly depends on the conditions of light and atmosphere that prevail. If they are diffused, the edges of the figure will soften and merge with the general texture of space. If they are bright and clear, the graphic character of the form, along with that of every other form, will stand out. Sometimes the two effects are combined, as in the scene of the nude blocking out the sun, and often the sinuous quality of the female form is so strong that it retains its graphic character even in a diffused ambience.

The Dominant Nude

In whatever way the figure is integrated into the design and mood of the picture, the nude is always a commanding presence. The process of developing that presence, and the total image, may be slow and extended, allowing the model time to work herself into the mood of the landscape, or it may be rapid and intuitive.

Several sequences were done at a pace determined by the natural rhythm of changes that occur with the rising sun. Another series involved a complex integration of figures in a forest setting where there were a number of factors to consider—the movement of water in a stream, the contrast of dense forest colors with the brighter hues of water and flesh, the dappled effect of light screened through the trees and reflected in the water. At other times, inspiration is immediate, or the conditions are such that fast shooting is essential. The photograph of the nude, whose red hair was perfectly complemented by the color and texture of the hay in a haystack was done on the spur of the moment on a trip through Colorado. The one of the nude and frozen waterfall were shot in less than a minute because of the severe cold. And yet in both these photographs, the subtle tonal qualities and fluidity of forms were captured with a kind of imperious grace.

The Female Form as Subject

In the studio, all the conditions of light, space, color, and composition (which are often so capricious in nature) come under the direct control of the photographer. The nude becomes an expression of pure sensuous form, encapsulating the abstract power of nature rather than merging with it. She becomes the sole graphic element, and the picture is literally constructed with her form. There is now a total identification between the female form and the pictorial entity; contour is line, flesh is color and texture. There is a further transformation in several pictures where line, color, and texture are shaped into suggestions of landscape or still life. The female body is both medium and subject, the place where nature and art meet and become almost indistinguishable.

The Fusion of Forms

The power and distinction of Robert Farber's style are the result of his ability to fuse natural and pictorial form, and, therefore, to give shape to the moods that bind us all to nature and human history. Human form, the landscape, and the objects and structures of man's making—these are the focus of our sensual awareness and thoughtful reverie, and the building blocks of Farber's art.

G olden Autumn *was photographed near New York City with a Nikkor 50 mm f/1.4 lens. The high-key light and golden leaves seemed to capture the richness of autumn. The light-ray effect was produced by a skylight filter coated with petroleum jelly. The film was ASA 160 slide film developed normally.*

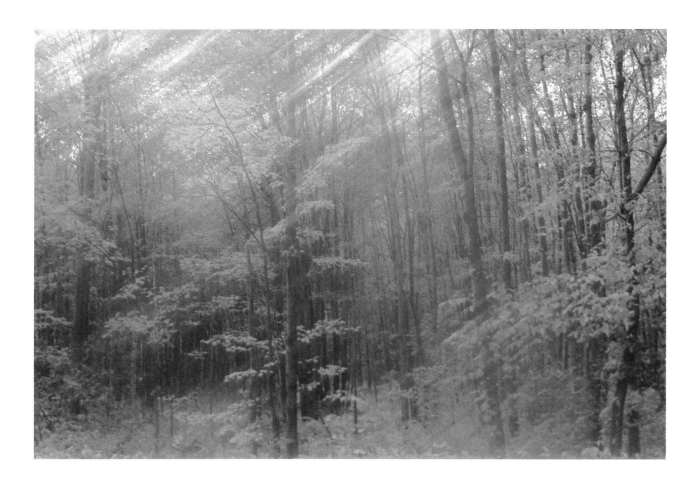

The Marsh *was photographed early in the morning (one of my favorite times for photography) near Hunter, New York. The model was not a professional, but sometimes that is better. She fits perfectly with the freshness of the morning scene. The ASA 400 film was pushed up to ASA 1600, and the Nikkor 50 mm f/1.4 lens was diffused by a skylight filter touched with hairspray.*

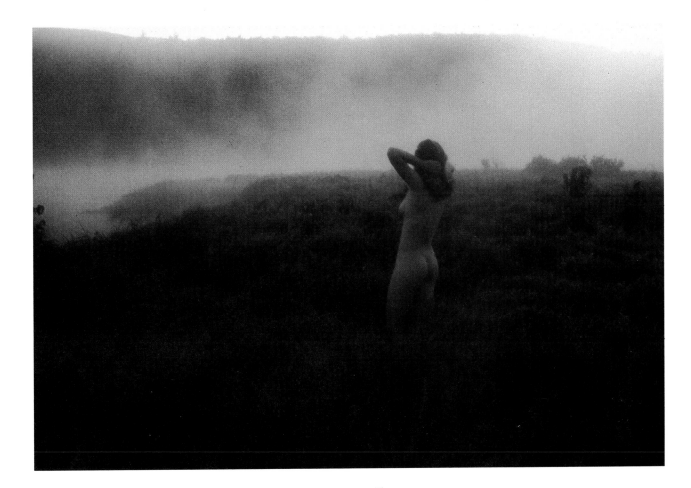

Death in Venice *was actually shot on the beach in Cannes, France. I like the way we see not only the man, but also the view he is contemplating. A Nikkor 80—200 mm zoom lens enabled me to carefully compose the image without getting too close and disturbing the subject. The film was ASA 64 reversal film rated normally.*

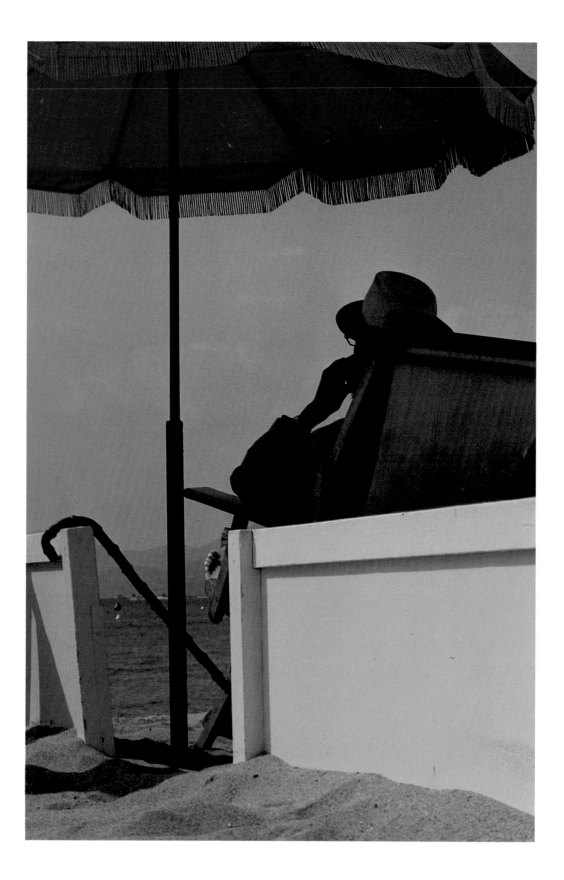

Snowbound *was photographed very quickly, for obvious reasons, using through-the-lens metering and a motor drive on a Nikon F2AS camera. Only about half a roll of film was shot, and that was accomplished in less than a minute, although the picture itself has an air of unruffled calm. The film was ASA 400 pushed to ASA 800, and the lens was a Nikkor 80—200 zoom. Hairspray was used on a skylight filter for added diffusion.*

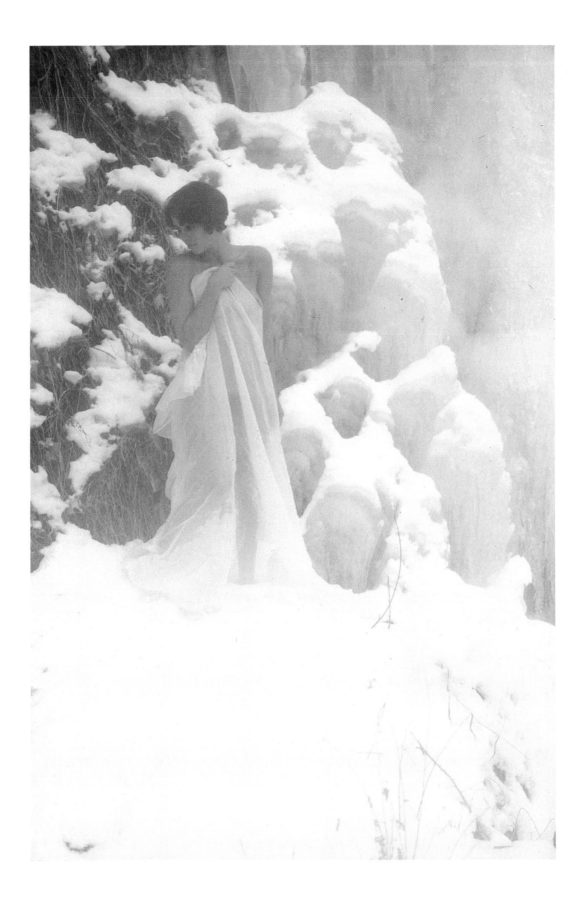

Windmill *was photographed in Barbados. I liked not only the scene, but also the combination of form, color, and texture present in this image. Both a polarizing and diffusion filter were used on the Nikkor 35 mm f/1.4 lens. The film was ASA 400 pushed to ASA 1600.*

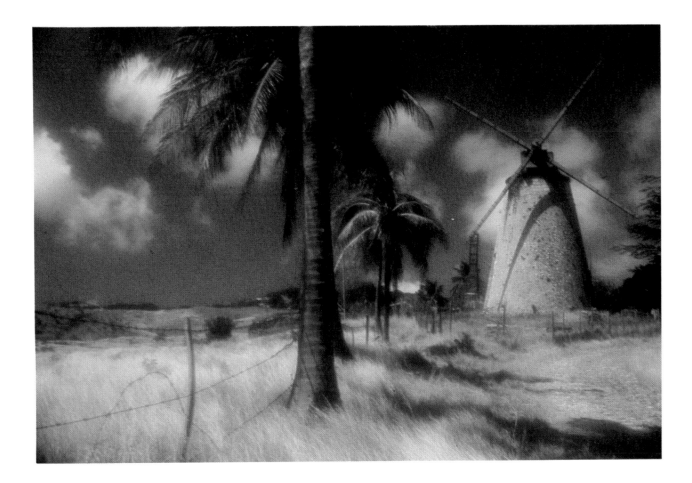

L ying in the Dandelions *is a midday, springtime shot which started out as a full-length study of the nude, but the textures and color seemed to make more sense with only the lower half of the figure showing. The Nikkor 50 mm f/1.4 lens was diffused by a skylight filter touched with hairspray. The ASA 200 film was pushed to ASA 800.*

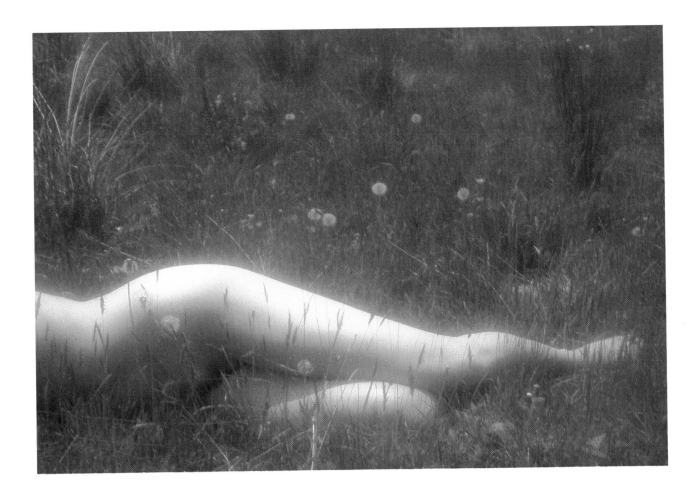

R ed *was photographed in Maine. The early-morning sun, along with the reflective surface of dew, lent warmth and intensity to the red tones of the bench. This red was further enhanced by pushing the ASA 160 film to ASA 1000.*

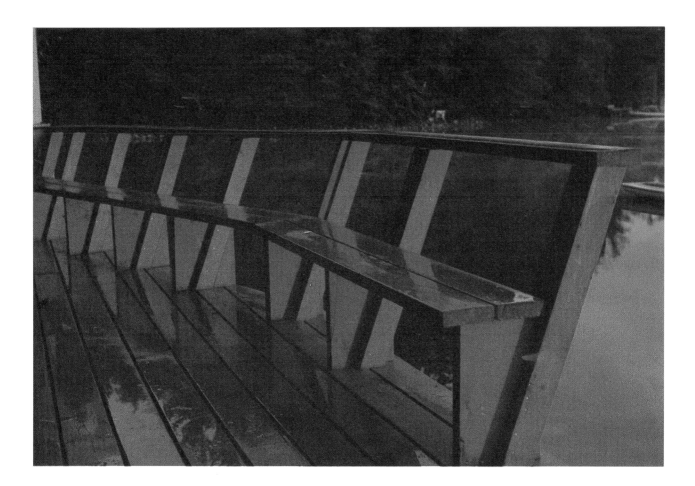

Devon Pond *was photographed for the subtle variations of color and form which appear within a very narrow monochrome range. Monochromes produce very strong and singular moods. The ASA 200 transparency film was pushed to ASA 1000. A Nikkor 80—200 mm f/4.5 zoom lens was used with a skylight filter coated with hairspray.*

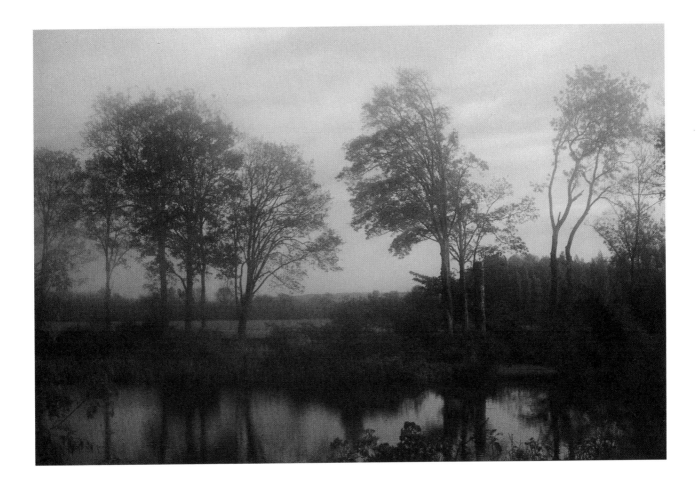

Haystack *was photographed under a high sun in Colorado. The color and texture of the hay went perfectly with the model's hair. The deep blue of the sky was brought out with a polarizing filter. A slight diffusion filter was used to take the harsh edge off the color. The camera was a Nikon F2AS with a Nikkor 50 mm lens. The film was ASA 400 pushed two stops to ASA 1600.*

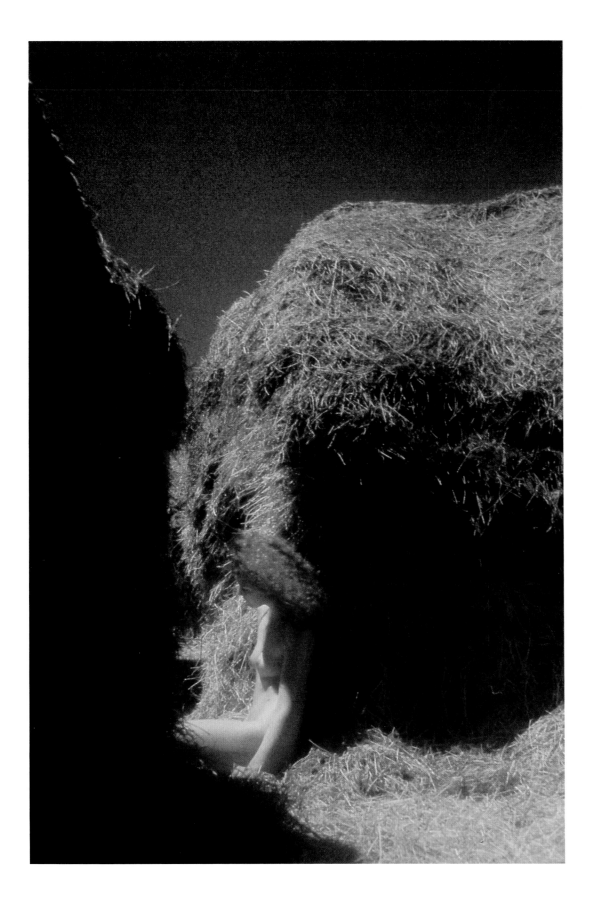

Torso Against the Sky *has a kind of sculptural monumentality which increases the sensual appeal of the subject. This photograph also achieves a kind of abstract purity of color and form. A polarizing filter was used to bring out the rich blue of the sky. This image was shot in Martinique using ASA 64 film rated normally, and a Nikkor 35 mm lens.*

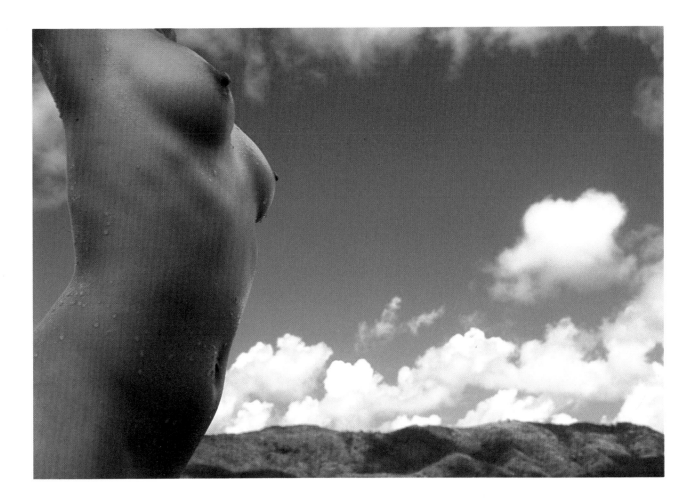

Country Mist *was shot in New England at six* A.M., *the time at which some of the most satisfying evocations of mood can be recorded on film. To take this image I used a Nikkor 80—200 mm zoom lens, ASA 160 film pushed to ASA 1000, and a skylight filter coated with hairspray.*

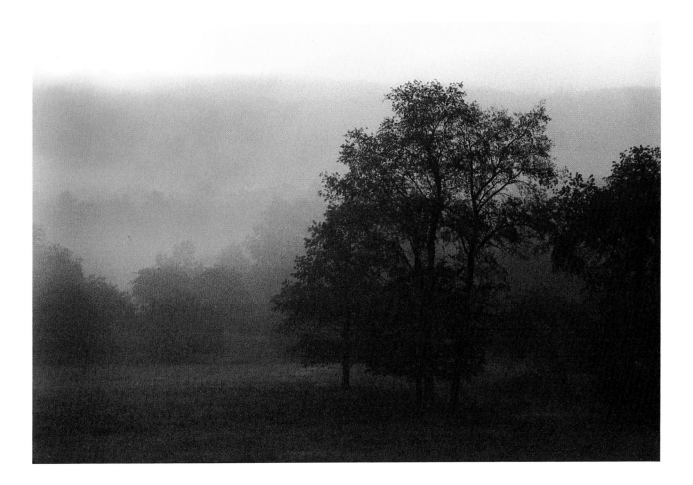

Moonscape *was particularly difficult to compose and bring off. The four nudes were shot from the floor with very little room for error in depth of field. Tungsten light was used with daylight film to achieve the warm tones. The diffusion comes from hairspray on a skylight filter. The ASA 200 film was pushed to ASA 1000 in development.*

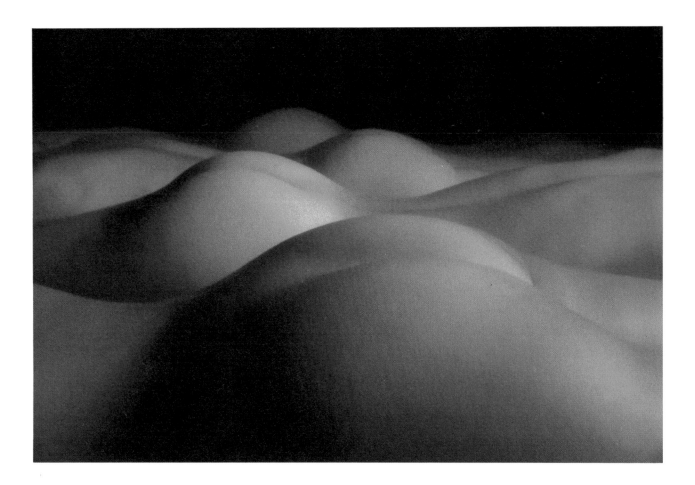

Rousseau's Studio *records the studio in France where the great Barbizon painter Theodore Rousseau worked. The mood is carried by objects that have aged to become almost natural rather than manmade. This mellowed effect was further enhanced by the use of a small amount of petroleum jelly on a skylight filter attached to a Nikkor 50 mm f/1.4 lens. The camera was a Nikon FTN with through-the-lens metering, and the film was ASA 160 pushed to ASA 640.*

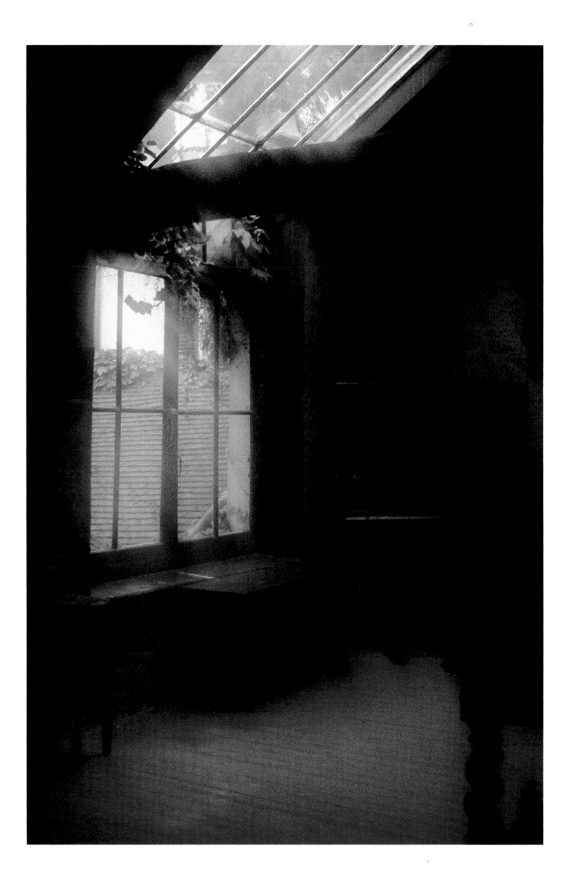

S ea Nymph *was actually taken in secluded woods not far from New York City. The glowing, white skin tones of the model were emphasized* by exposing for the shadow area of the rock rather than the nude herself. The ASA 200 film was pushed to ASA 800, and the Nikkor 80—200 mm zoom lens had a skylight filter coated with hairspray attached to it.

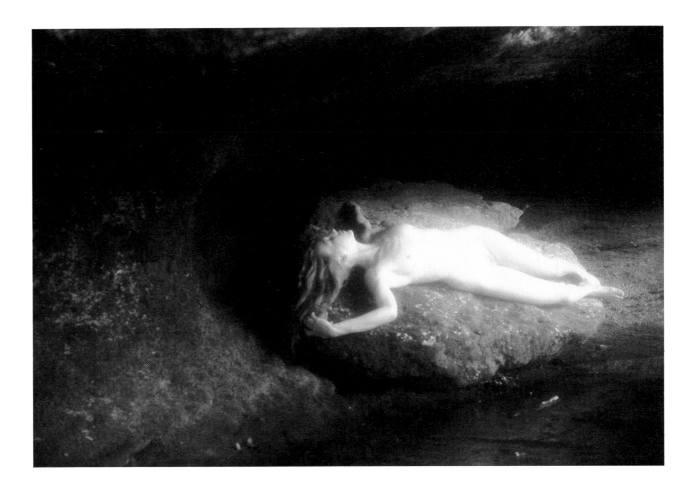

Red Shed *is almost a study in primary colors, climaxing in the saturated, light-struck red of the barn. This red balances and focuses the rest of the composition. The brilliant midday sun was slightly diffused by hairspray on a skylight filter in front of the lens. The film was ASA 200 pushed two stops to ASA 800.*

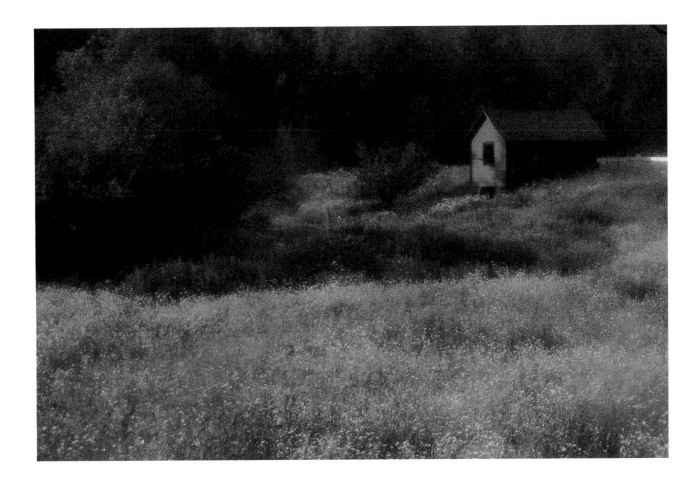

Reflection in the Window *brings together several objects with interesting textures as they were found in an old estate in Southhampton, New York. The actual hand of the nude in contrast with the reflection creates a connection with the viewer. A slight diffusion filter was used in front of the Nikkor 50 mm f/1.4 lens. The film was ASA 200 pushed to ASA 800 in processing.*

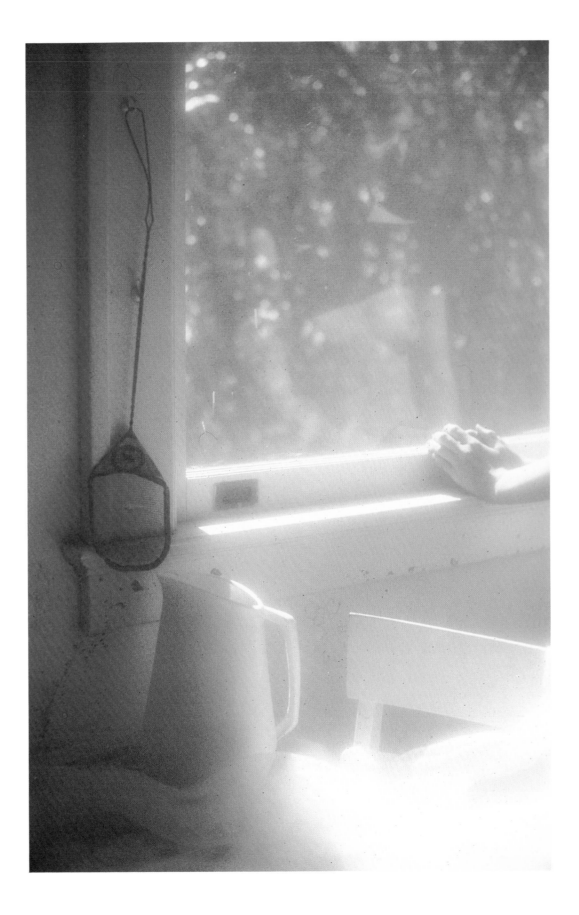

urves is a statement about the nude as sensuous line. Obtaining the clarity of drawing is difficult, it depends on subtle lighting. Here I used a Balcar Studio Strobe with one head and a soft box, and exposed for the highlights. The camera was a Nikon F2 with a Nikkor 50 mm lens. The film was ASA 200 rated normally.

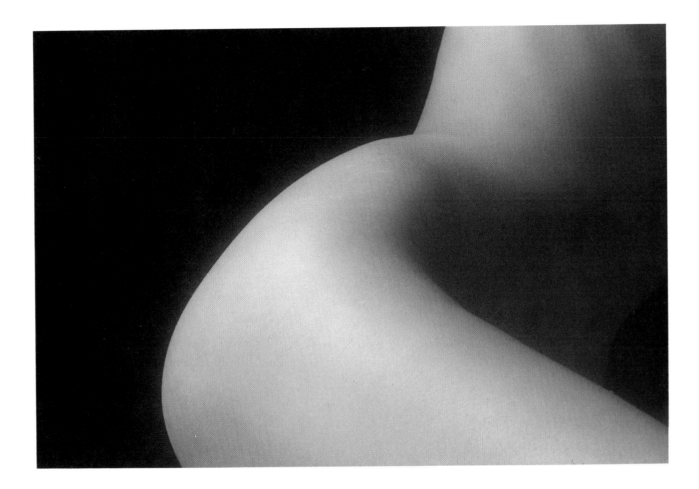

Grass *was shot on a very overcast day on Cape Cod. I was interested by the subtle banded tones of the grass as it moved in the wind. The individual blades seemed like brushstrokes. In order not to destroy the clarity of the detailing I used no filtering on the Nikkor 80—200 mm zoom lens. The film was ASA 200 pushed to ASA 800.*

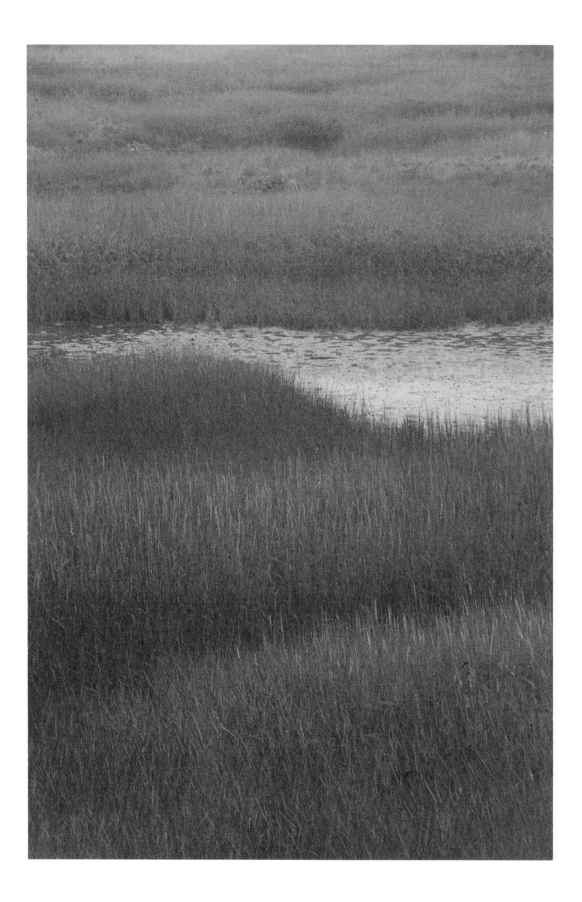

*S*ilhouette *contrasts the haziness of the early morning landscape with the clearly drawn outline of the nude form, which blocked out the rising sun to create an opaque, black shape. This was shot during a particularly spectacular sunrise in upstate New York. The film used was ASA 64, and the lens was a Nikkor 35 mm f/1.4.*

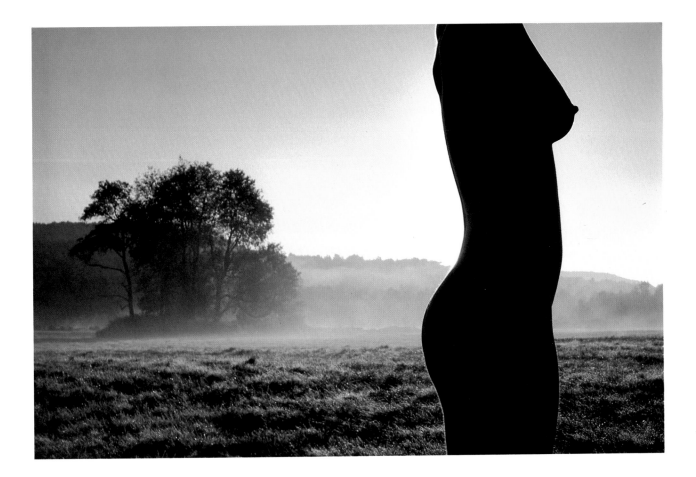

L egs is a study in white done in natural light. Some of the most interesting moods can be achieved by emphasizing the subtle variations of tone in basically monochrome fields such as this. The ASA 200 slide film was pushed to ASA 1000, and hairspray was applied to the skylight filter on a Nikkor 35 mm f/1.4 lens.

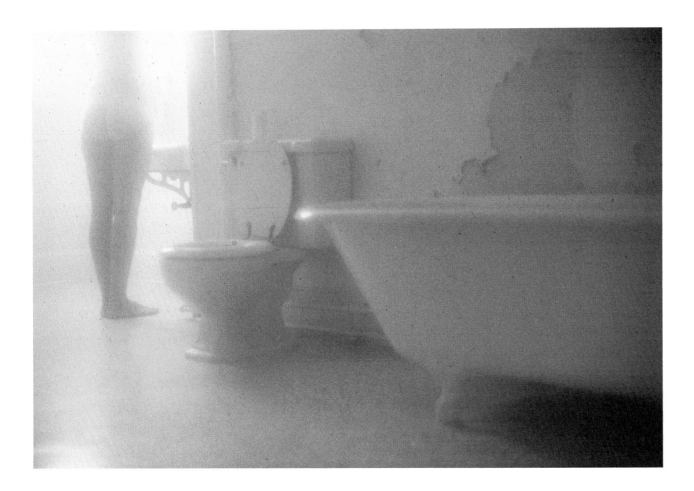

Remembering *used natural light from a window. The old man came into my studio asking for a donation to his church and I asked him to sit for a photograph. I used a Nikkor 105 mm f/2.5 lens with a skylight filter.*

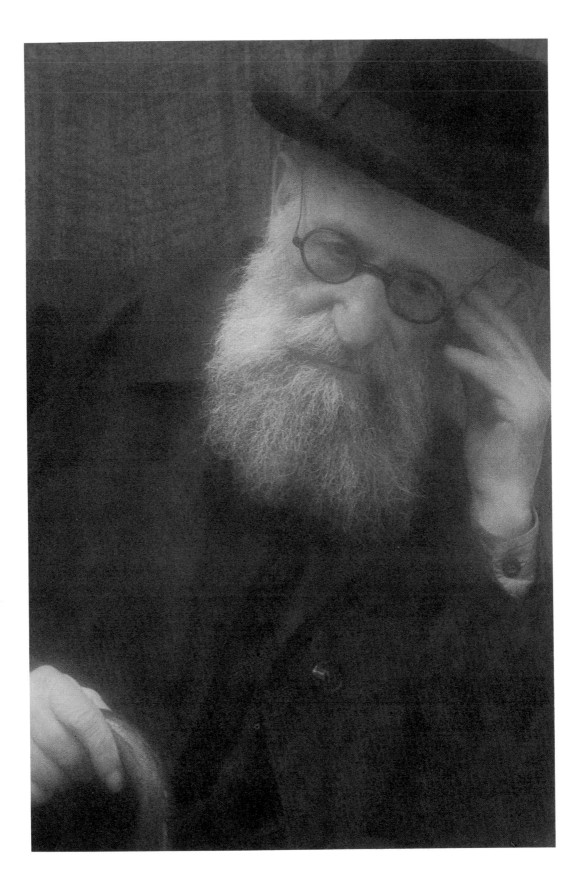

Morning Coffee *integrates indoor space and out-door light with an intricate pattern of shadows and grids. The film was exposed for the high-lights so that such subtle effects as the reflection along the back of the nude would bring out the graphic design of the forms. The ASA 200 film was pushed to ASA 800.*

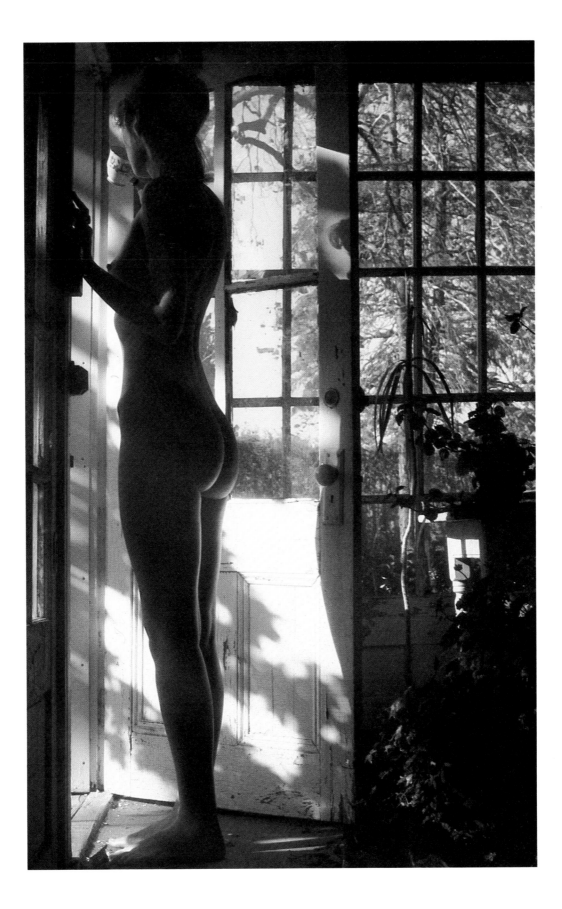

Flower Box *is an example of the pictorial interest created by a single burst of color in a basically monochromatic photograph. This was taken in the French countryside using ASA 160 film pushed to ASA 640. The image was diffused by a skylight filter coated with petroleum jelly. The camera was a Nikon FTN, and the lens was a Nikkor 50 mm f/1.4.*

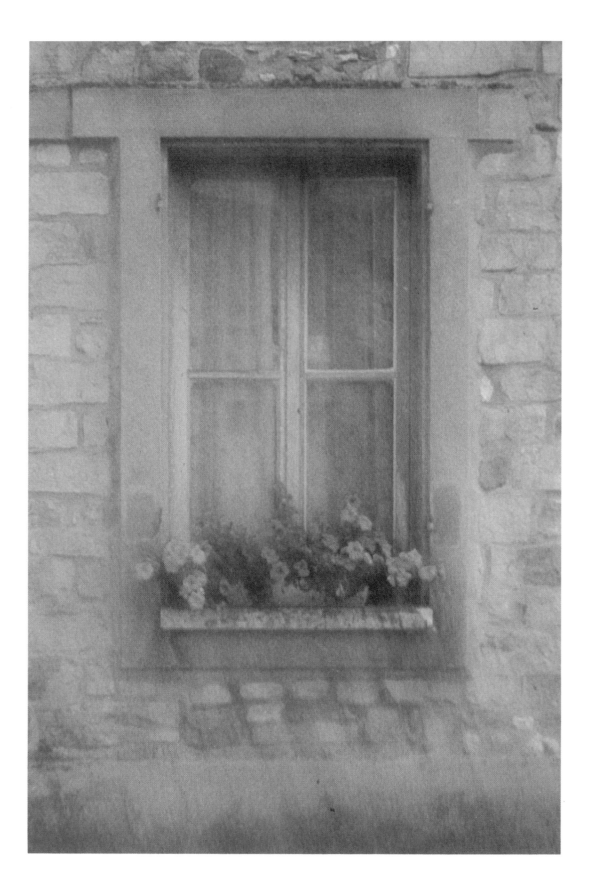

C ypress *was photographed on a cloudy day in Carmel, California, with a medium-blue filter, so that both the softness of the atmosphere and the sharpness of the outline are emphasized. The ASA 160 film was rated normally.*

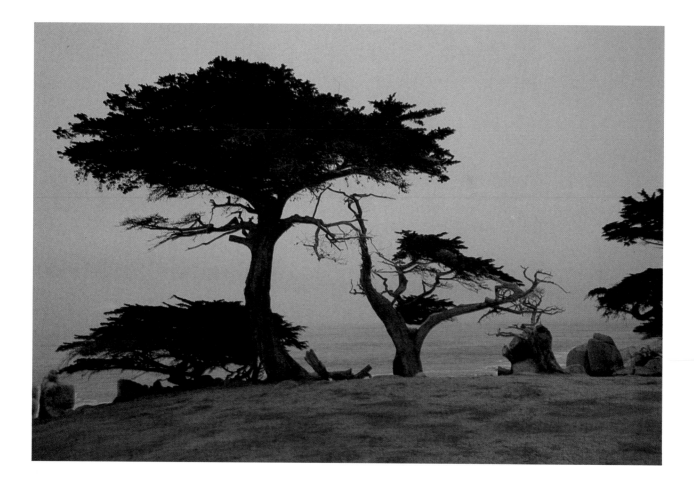

Hips *involved two models, which can lead to fascinating play with various formal and linear combinations. One of the problems, of course, is keeping the models pretty much the same type so that the harmony of proportion, color, age, etc., is retained. This shot was done in my studio using a Balcar Studio Strobe with one head and a soft box. The ASA 200 film was rated normally.*

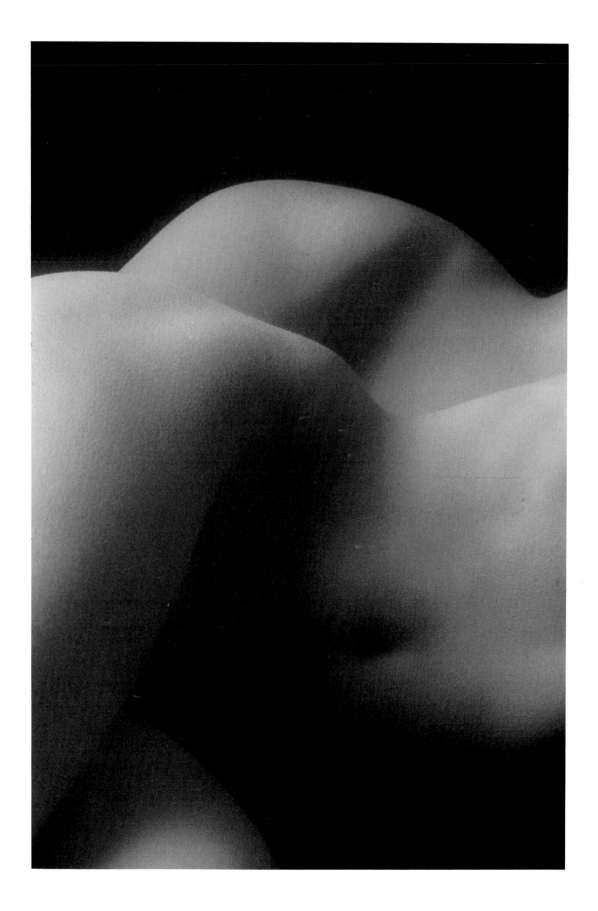

Shadow strikes a strange balance between exterior and interior space. The outside scene appears as a picture framed by the inside scene. The entire photograph is rigidly structured and almost seems to be painted in tones of light and shadow. This photograph was taken in an unoccupied estate in Southhampton, New York, with ASA 200 film pushed to ASA 1000.

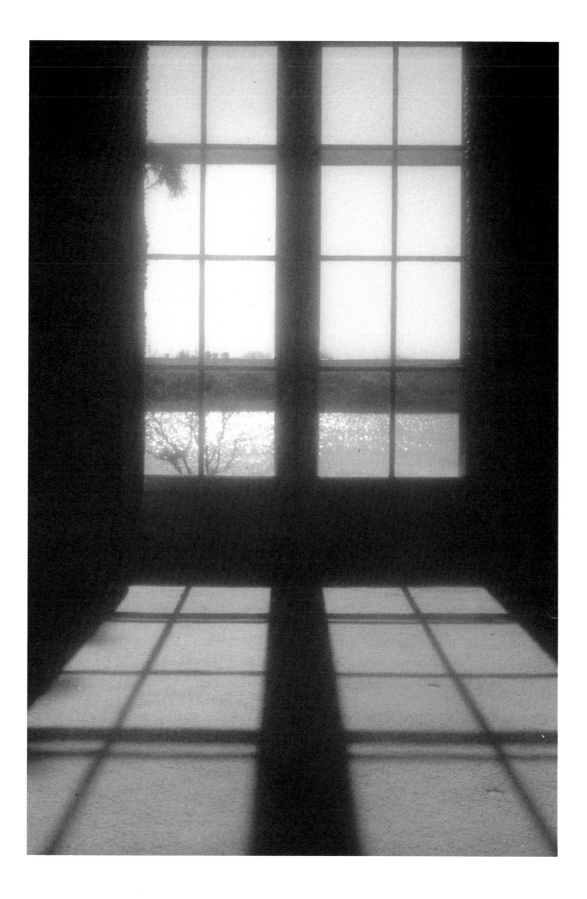

The Field *was shot on a farm in Bridgehampton, New York. The model struck a variety of poses before she came to this one which focuses the entire scene. A skylight filter coated with hairspray was used for diffusion. The film was ASA 200 pushed to ASA 1000.*

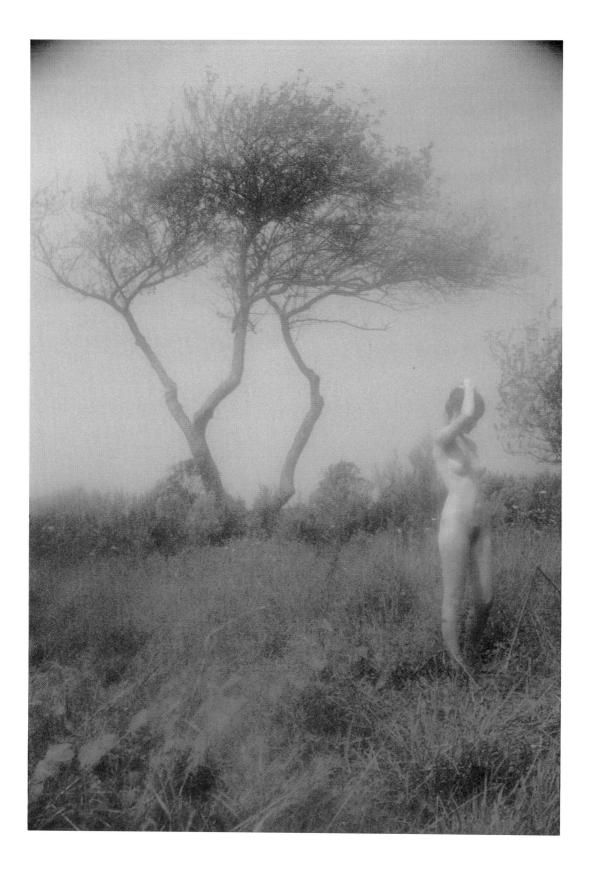

*S*truggle *was photographed in my studio. I used daylight film with tungsten lighting to create the warm tones. The ASA 160 film was pushed to ASA 1000. Gauze was used in front of the Nikkor 105 mm f/2.5 lens for added diffusion. The camera was a Nikon F2.*

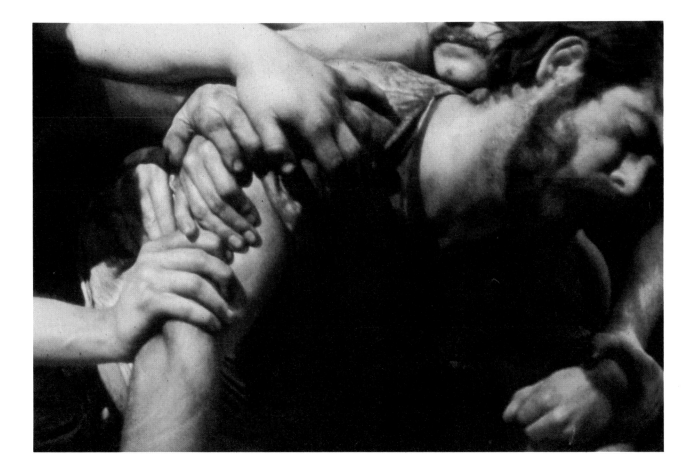

Forest at Fontainebleau *was photographed in the area where the Barbizon school of painters flourished in the nineteenth century. A number of Impressionists, as well as Paul Cézanne, also worked here. The light-ray effect was produced by a skylight filter coated with petroleum jelly. The ASA 160 film was pushed to ASA 640.*

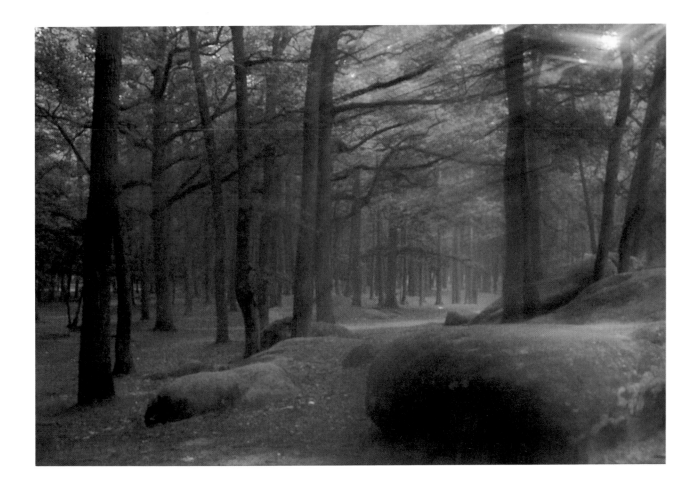

Petals *was shot in an old house in New England. The film was exposed for the sun coming through the window to emphasize the spotlight effect. The natural diffusion of the light coming through a curtain was enhanced by a skylight filter coated with hairspray. The lens used was a Nikor 50 mm f/1.4, and the film was ASA 200 pushed to ASA 800.*

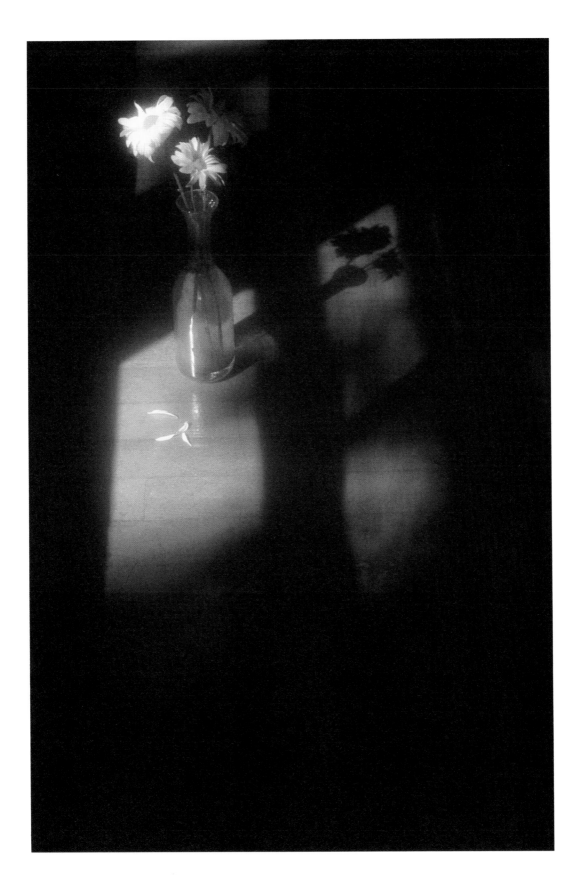

waiting the Plow *was a test of concentration. I was trying to focus on the moment when the turn of the horse's head would complete the composition and at the same time listen to the friendly chatter of the man who owned this farm in South Wales. An 80—200 mm f/4.5 zoom lens was used on a Nikon F2AS camera with through-the-lens metering. Diffusion was enhanced by a skylight filter coated with petroleum jelly and ASA 400 film pushed to ASA 1600.*

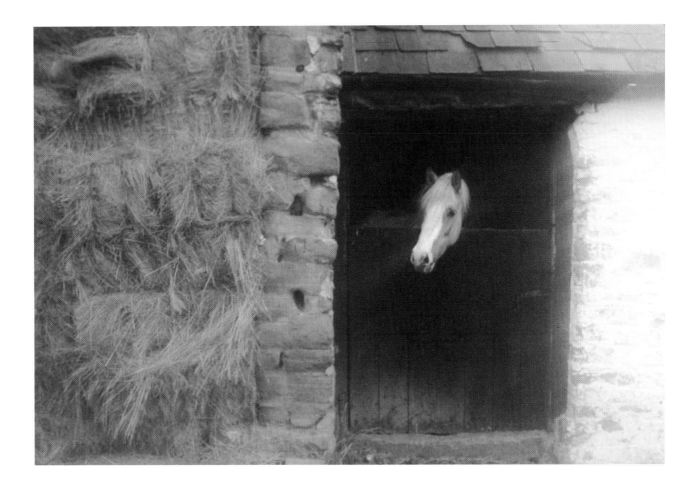

S itting in the Window *was taken at the Black Bass Inn in New Hope, Pennsylvania. I found this location while looking in the Pennsylvania countryside for an area of snow to use as the location for "Snowbound". The diffusion of light was enhanced by a skylight filter with petroleum jelly, and the ASA 200 film was pushed to ASA 800.*

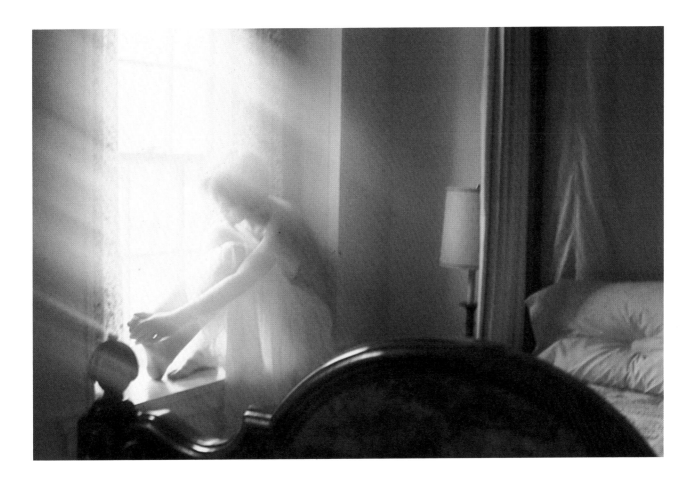

Cross's Flowers *is so named because it was photographed at a farmhouse owned by friends named Cross. The comparison of forms and textures in basically the same type of light stretches the facility and feeling of the viewer. Here a Nikkor 50 mm f/1.4 lens was used with a slight diffusion filter, and the ASA 400 film was pushed to ASA 1600.*

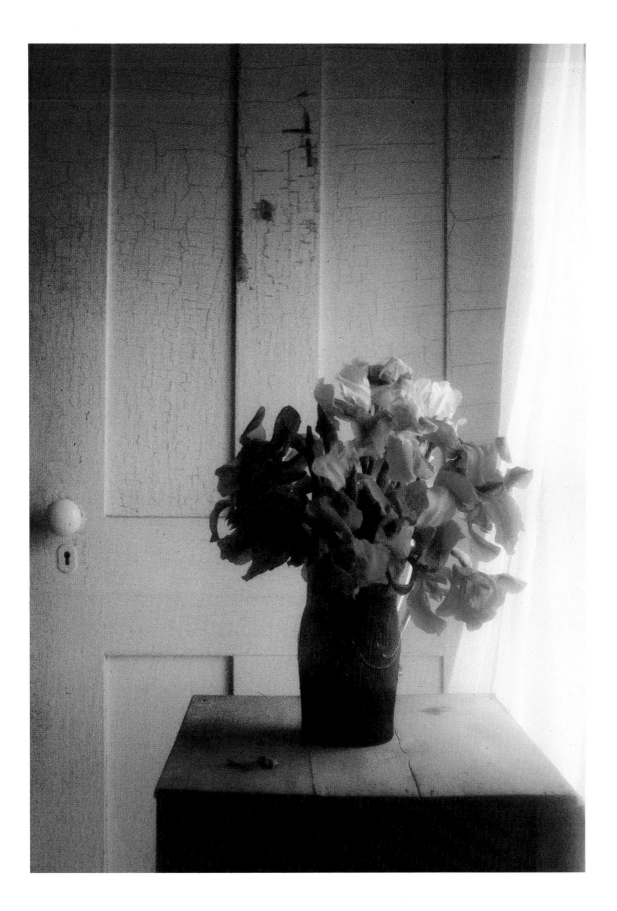

*C*hoir Robes *was one of those chances that liter-
ally and unexpectedly open up a private world.
Formally the image is appealing, but the idea
that the door is always open, at least on Sundays, also
carries the intrigue of human habit. This photograph was
shot at an old church in Barbados on ASA 400 film
pushed to ASA 1600.*

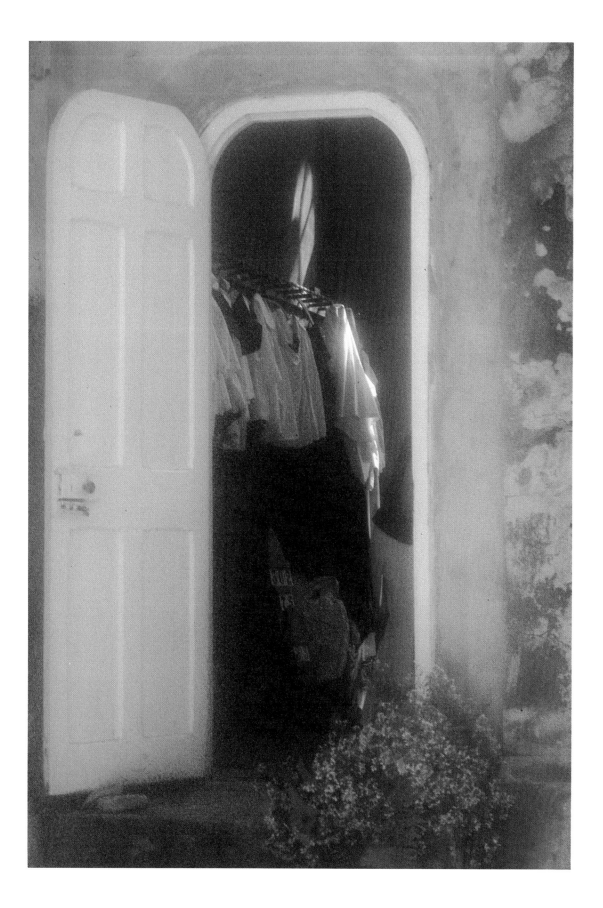

Hayfield *was taken in the Berkshire mountains of Massachusetts on an early summer morning. The ASA 160 film was pushed to ASA 1000 to break up the emulsion and create an almost monochrome effect. A Nikkor 35 mm lens was used along with a skylight filter coated with hairspray.*

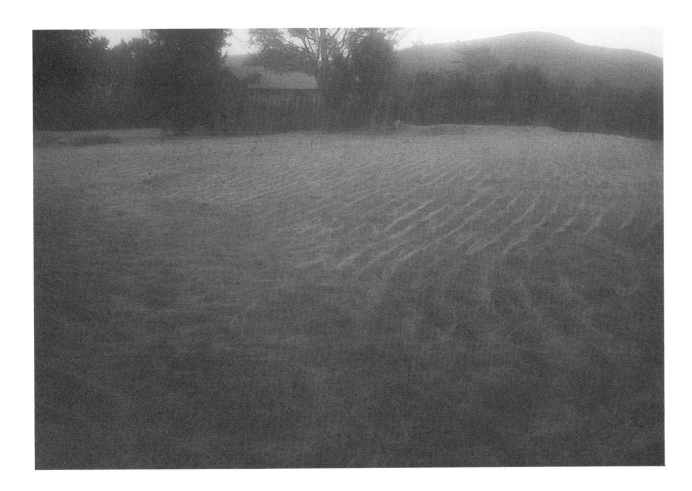

D rip *shows how old objects and surfaces lend themselves to rich effects of texture and composition. Even the simplest and most abstract subject can have an inherent drama. This closeup was achieved by using a Nikkor 105 mm f/2.5 lens. Natural light from a window was used, and the ASA 200 film was pushed to ASA 800.*

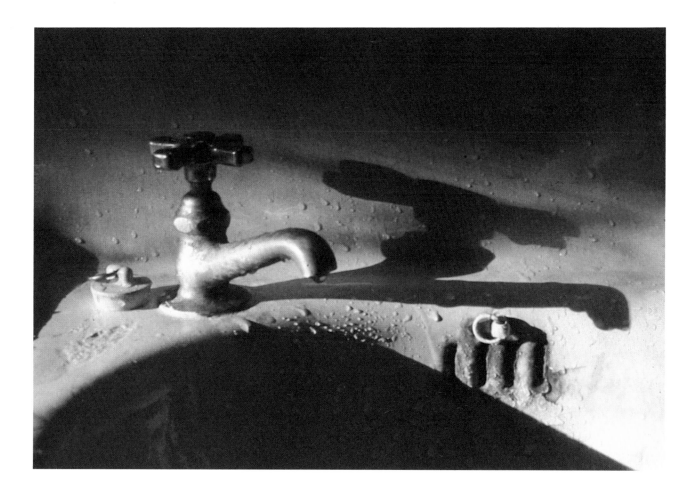

Roots *takes advantage of the high-key midday light. The white skin tones and brilliant blonde hair of the model were emphasized by overexposing one stop, which also eliminated the blueness of the Jamaican sky. This picture was shot near the beach at Ocho Rios with a Nikkor 50 mm lens and a skylight filter coated with hairspray. The ASA 400 transparency film was pushed to ASA 1600.*

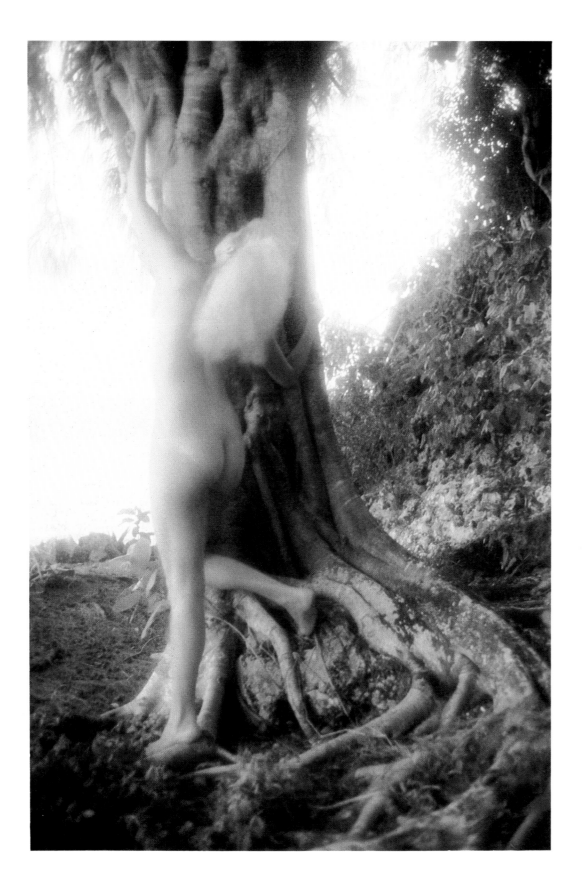

L ight Fixtures *was shot in an old convent near New York City. The film was exposed for the highlights so that the dark areas receded. The ASA 160 film was pushed to 640, and diffusion was obtained by the use of a skylight filter coated with hairspray.*

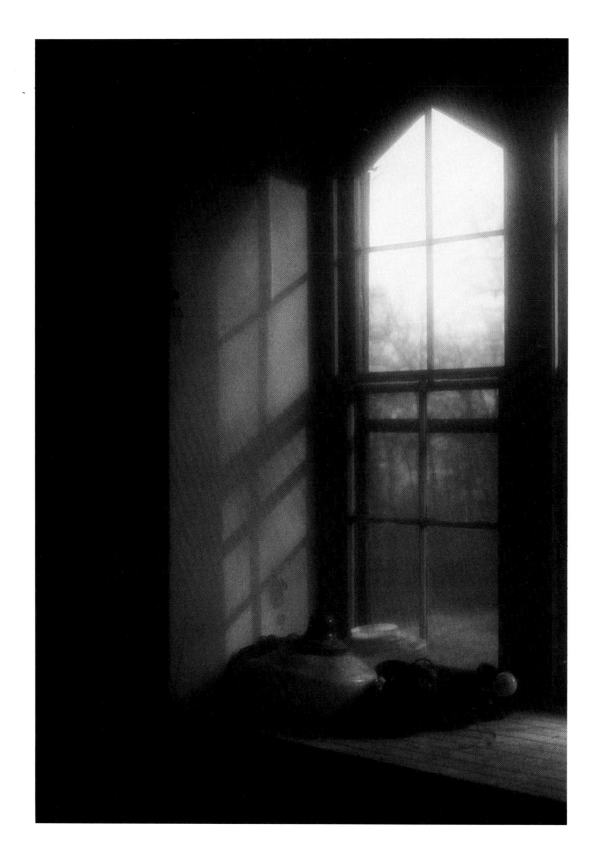

F or Robert Frost *was used as a book cover for an anthology of Robert Frost's poetry, although the photograph was taken in England rather than New England. The light-ray effect was obtained by using petroleum jelly on a skylight filter attached to a Nikkor 50 mm lens. The ASA 200 film was pushed to ASA 1000.*

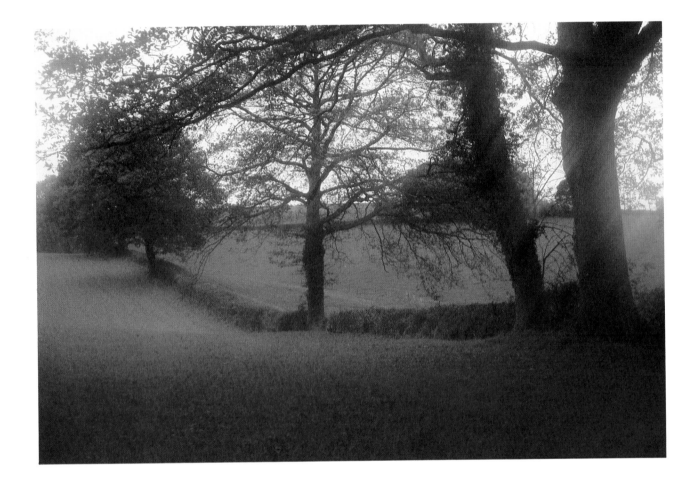

Alley *is one of my earliest mood photographs. It was shot in a small Portuguese fishing village. There was very little chance to set up as the old man approached the end of the alley, but the picture snapped into place almost automatically. It was shot on ASA 64 film with a Nikkor 50 mm lens mounted on a Nikon Photomic FTN body.*

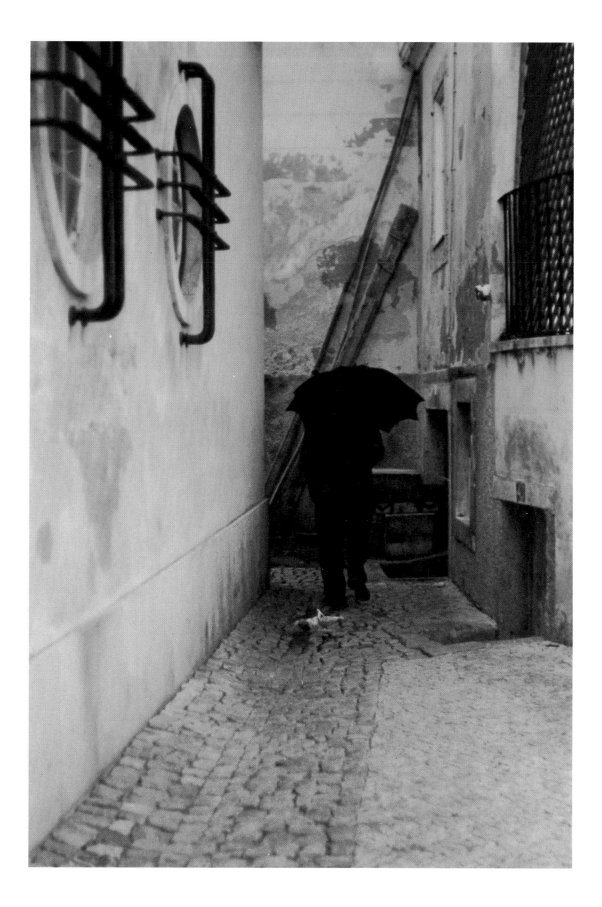

Empty Chairs *emphasizes the graphic character of the scene with strong shadows and perspective lines. This picture was taken on the New Jersey shore with a Nikkor 35 mm lens and ASA film pushed to ASA 800.*

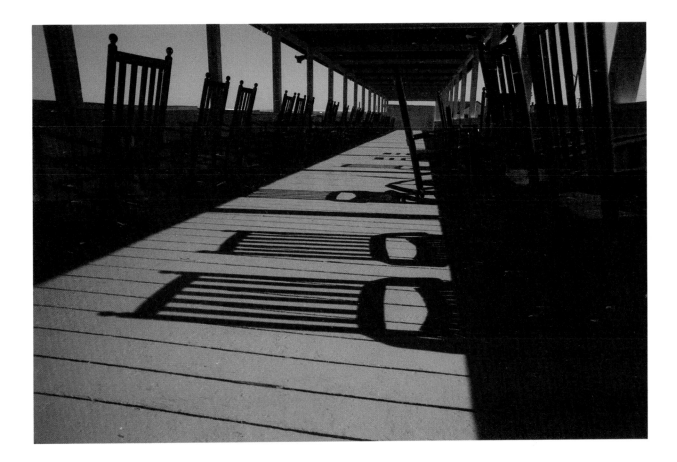

Twisted *is a studio shot photographed in natural light from a skylight. The model struck a variety of interesting poses, but this is the one which worked best. The film was ASA 160 pushed to ASA 640 in development.*

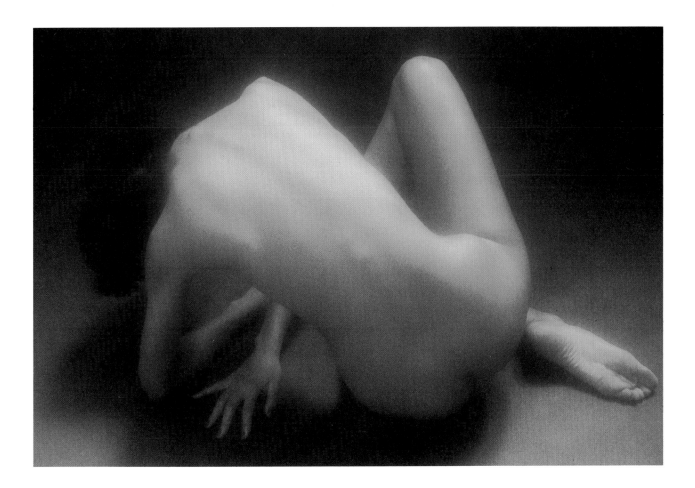

Abandoned *is the inside of a deserted farmhouse in upstate New York. The photograph was taken through a window, and the composition was almost completely determined by the fact that I had to press the lens directly against the window in order to avoid any reflections. The ASA 200 film was pushed to ASA 800.*

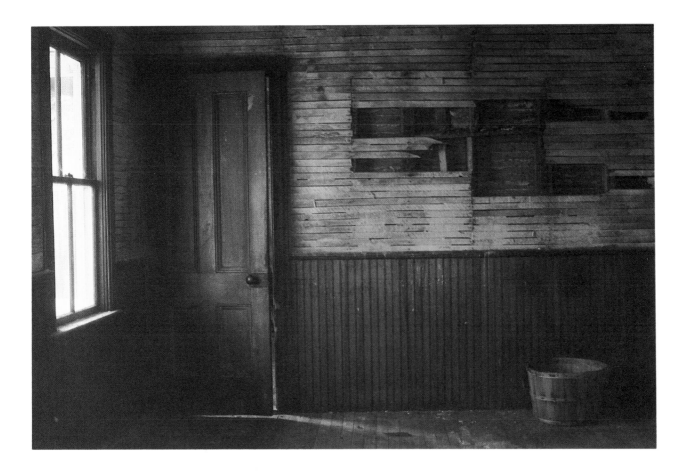

The Desolate Farm *was first seen as I sped by on a highway in New England and couldn't get off. As it turned out, the light was much more appropriate when I returned later. This is one of the situations where I felt very physically and emotionally in tune with the image. This photograph was made on ASA 160 film which was pushed to ASA 1000. The lens was a Nikkor 80—200 mm f/4.5 zoom.*

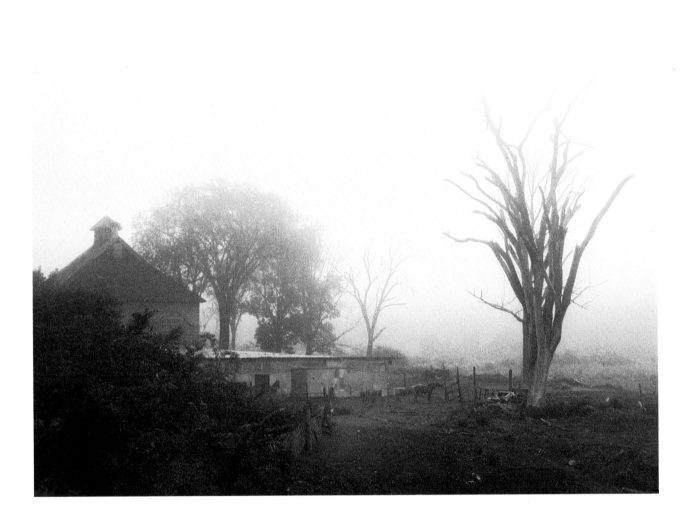

Lady of the Desert *was shot in New Mexico near the Arizona border. It was midday so the light was at its maximum intensity, particularly when compared to the light of New England and the Eastern United States, where I usually photograph. The film was slightly underexposed to saturate the colors, and a polarizing filter was used on the Nikkor 35 mm lens to enhance the blue sky.*

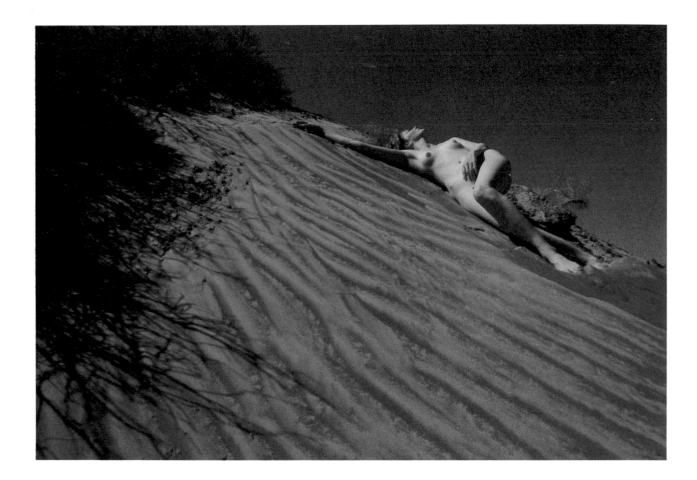

F ire Island *has natural and manmade forms that complement each other. In a shot like this the curves of the landscape have graphic values similar to those of a nude figure. Gauze was used to diffuse the light through the Nikkor 50 mm lens. The film was ASA 160 pushed to ASA 640.*

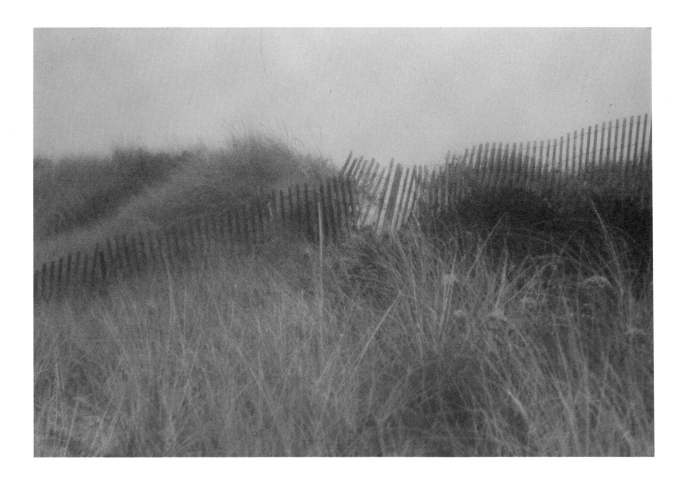

L azy was photographed on an old farm in Bridgehampton, New York. Something about the contrast of the model's texture and color with those of the old pump just seemed to work. The camera was a Nikon, and the lens was a Nikkor 43—86 mm zoom diffused by a skylight filter coated with hairspray.

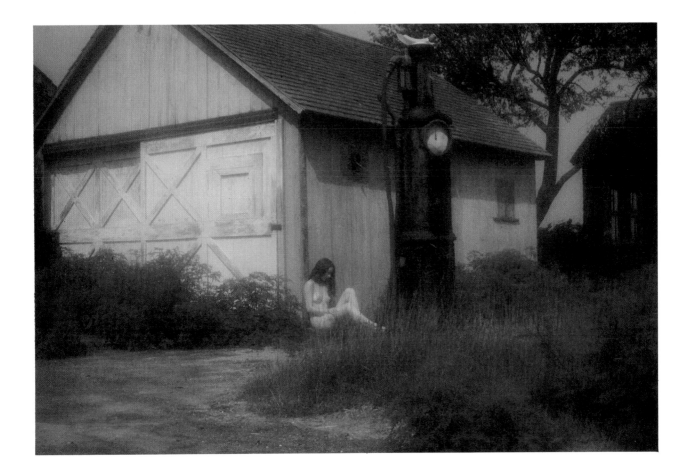

Reflections in the Mist *captures the early morning light in upstate New York. The scene was shot across the pond using a Nikkor 80—200 mm zoom lens. Instructions had to be shouted to the model, but the mood soon established itself for both of us. The natural diffusion of the early morning light was enhanced by hairspray on a skylight filter. The film was ASA 400 pushed to ASA 1600.*

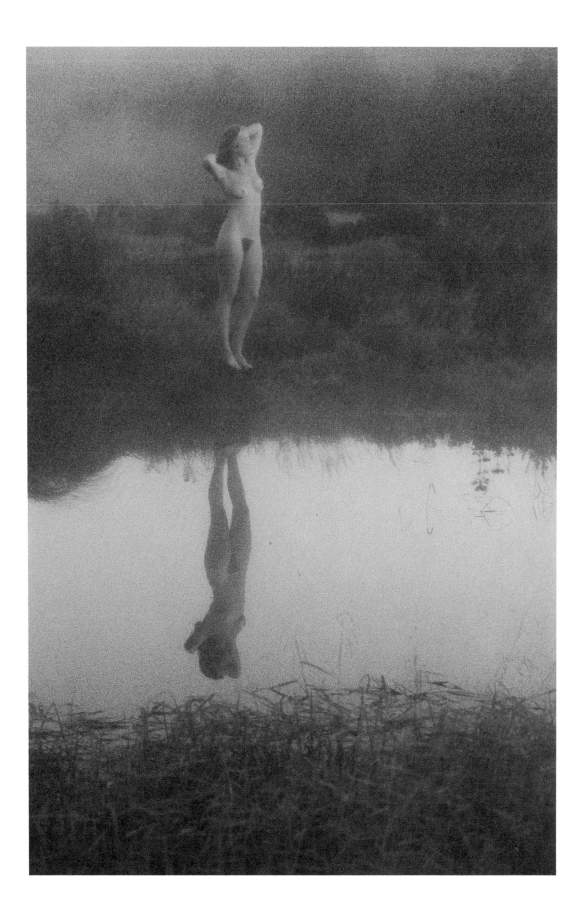

MOODS

Edited by Michael O'Connor.
Designed by THE GRAPHIC IMAGE.
Graphic production by Ellen Greene.
Set in 10 point Americana by TruFont Typographers.
Printed by Rae Publishing Company, Inc.